'We Go To The Gal series of Dung Beet designed to make so approachable for the under 5s. Printed in bold colors and written in clear, simple English, each book will drag families in to the darkest recesses of the collective unconscious, for their broader cultural benefit.

Miriam Elia (MSC, RAC, AIDS) the author and illustrator of this book, is headteacher working at the London School for the Poor and Ignorant. She specializes in teaching art and Zen Buddhism to young minds. Co author Ezra Elia is an expert in self-hatred and words.

This book belongs to:

THE NEW WORDS READING SCHEME

The Dung Beetle 'New Words' reading scheme will maximize your child's ability to remember long words and difficult concepts. At the bottom of each page are three 'new words' which summarize core emotional responses to the artwork.

We recommend that you read these new words with your child as often as possible. In this way your child's unique opinions will be gradually ground down so as to develop proper up-to-date critical thinking skills.

The future of British art and cultural standards depends on our children grasping the full significance of contemporary art, so that they can lead full, happy and conflicted lives for many generations to come.

Book 1a

THE DUNG BEETLE NEW WORDS READING SCHEME

We go to the gallery

by
M. ELIA and E. ELIA

with illustrations by
M. ELIA

Dung Beetle Ltd © 2015
First Published 2014 London, England

We are going to the gallery.

Mummy wants to show us the art.

gallery mummy art

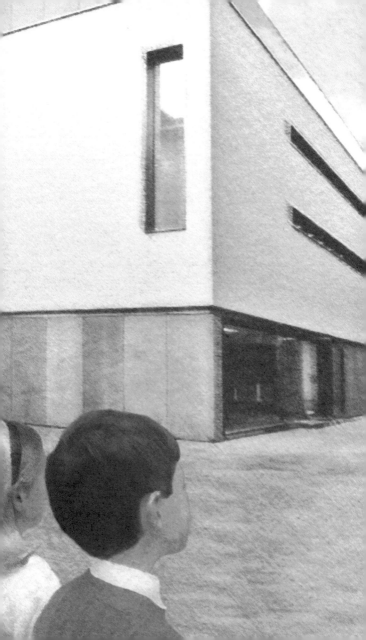

"Is the art
pretty?" says Susan.

"No," says Mummy,
"Pretty is not important."

pretty **not** **important**

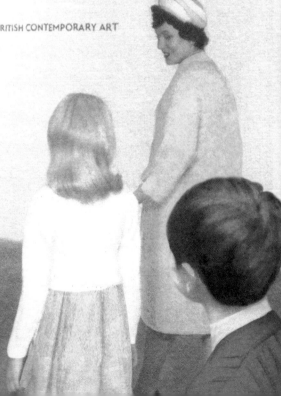

THE DEATH
OF MEANING

BRITISH CONTEMPORARY ART

John does not understand.

"It is good not to understand" says Mummy.

John doesn't understand

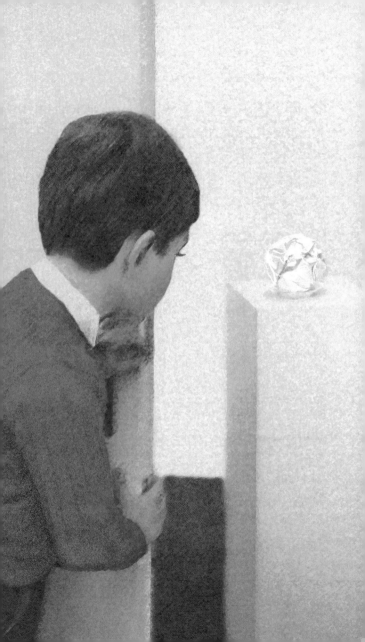

There is nothing in the room.
John is confused.
Susan is confused.
Mummy is happy.

"There is nothing in the room because God is dead," says Mummy.

"Oh dear," says John.

new words God dead confused

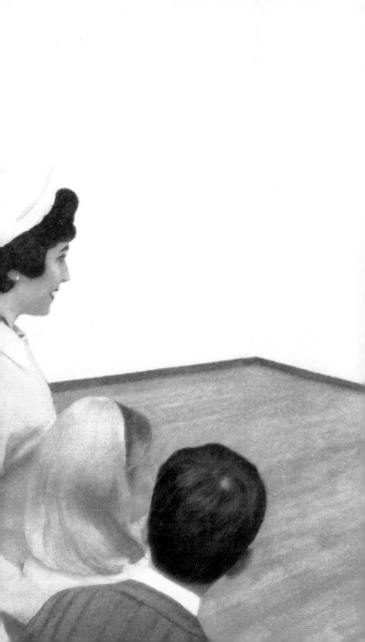

John sees the painting.

"I could paint that,"
says John.

"But you didn't,"
says Mummy.

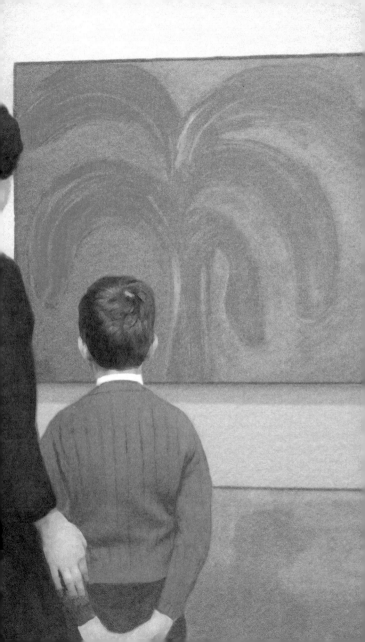

The canvas is blank.

Susan is blank.

"Gosh! They are naked!"
says John.
"Is it bathtime?"
says Susan.
"No, " says Mummy. "It
is body objectification
time."

new words naked body object

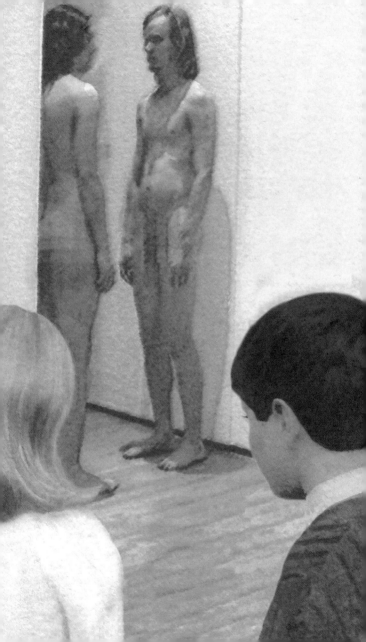

"The words are very sad," says Susan.

"They are very funny!" says John.

Susan does not think they are funny.

words funny sad

"Why is there a penis on the painting?"

"Because God is dead and everything is sex," says Mummy.

new words penis sex painting

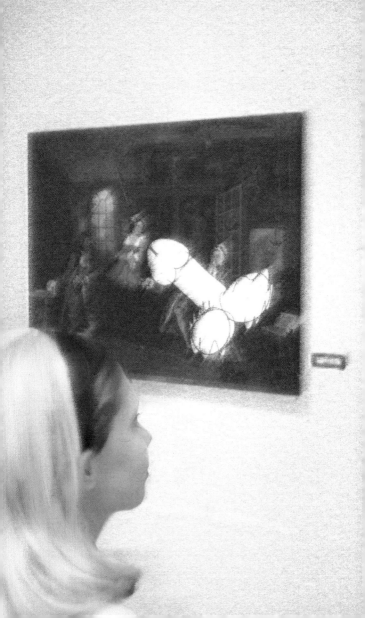

John sees the big vagina.

"That's a big vagina," says John.

"Big vaginas are feminist," says Mummy.

John is scared.

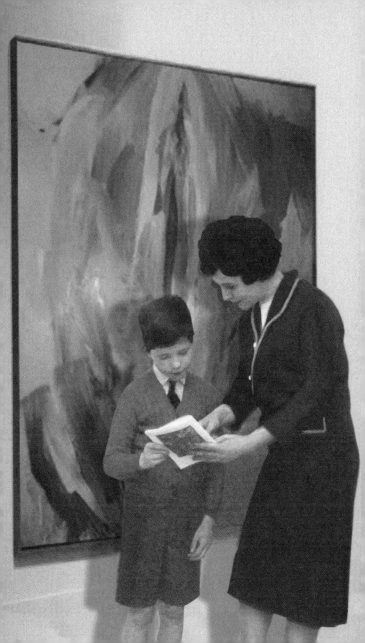

The man is a woman.
The woman is a man.

John is excited.
John is confused.

John doesn't know
what he wants.

new words man woman confused

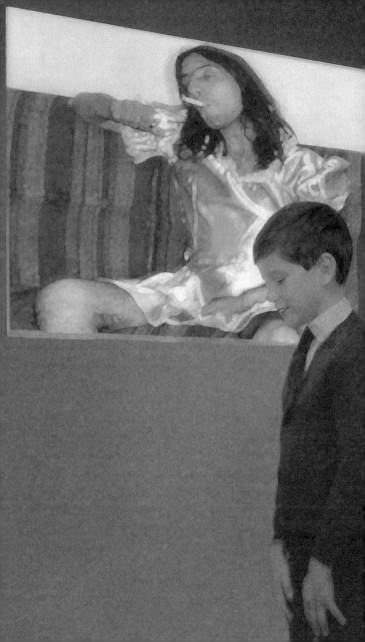

"Look!" says John,
"the rabbit is cut in
half."

"I think it is happy,"
says Susan.

"Both halves?"
says John.

new words **rabbit** **half** **happy**

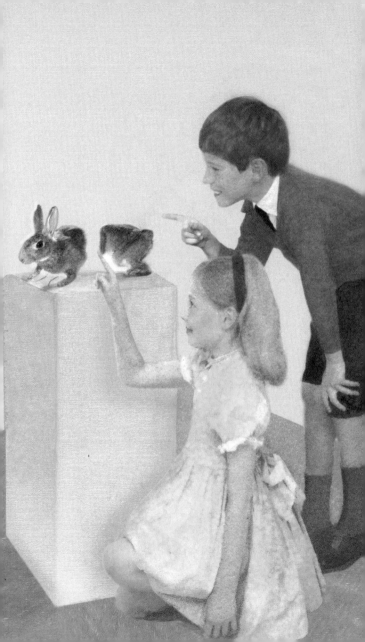

"There is oil on the floor," says John.

"The oil is all the blood shed by the US government in its illegal wars," says Mummy.

"Golly!" says John.

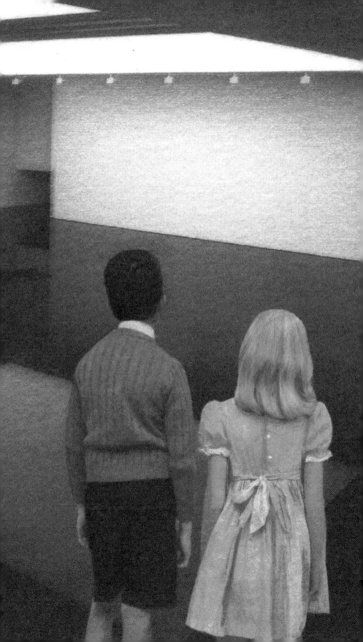

"The rubbish smells,"
says Susan.

"It is the stench of
our decaying Western
civilization,"
says Mummy.

new words rubbish smells western

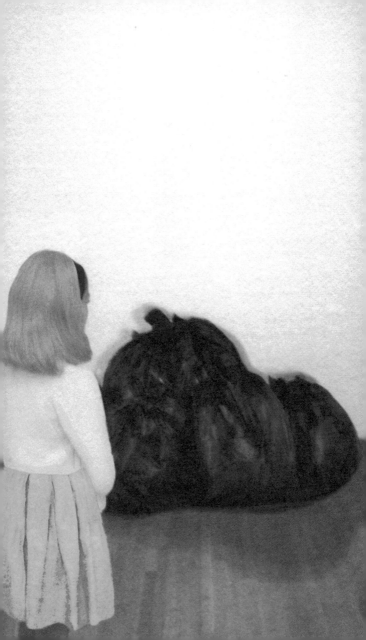

"I want to play with the balloon," says John.

"Only venture capitalists can play with this balloon," says Mummy.

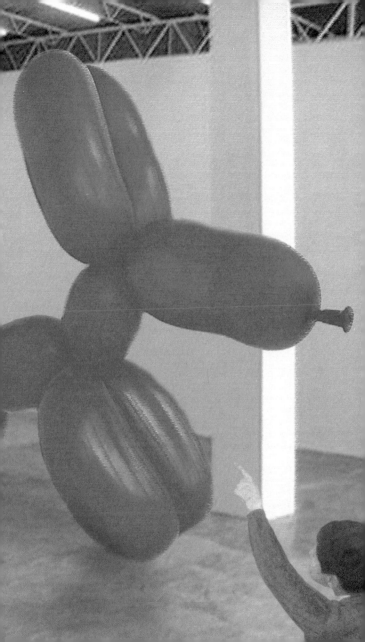

The man is screaming.

Mummy is crying.

Susan is quiet.

new words quiet screaming man

The waterfall video does not stop.

"Does the waterfall stop?" says John.

"No!" says Mummy, "death is an illusion."

Susan needs the toilet.

new words waterfall death toilet

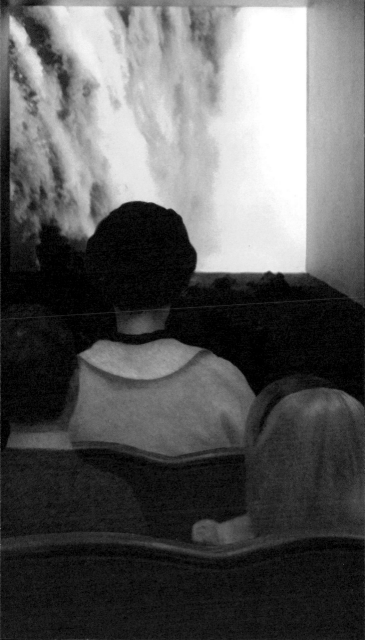

"Gosh! The living room is in the gallery!" says John.

"And irony is in our living room," says Mummy.

John feels violated.

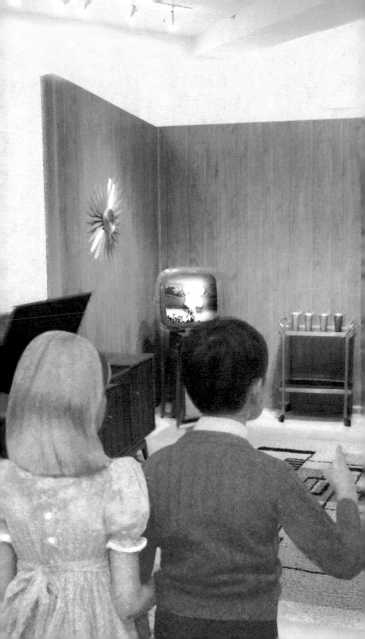

We are leaving the gallery now.

"Did you enjoy the gallery?" says Mummy.

"I feel strange," says Susan.

"Me too," says John.

"It is the modern condition," says Mummy.

new words **strange modern condition**

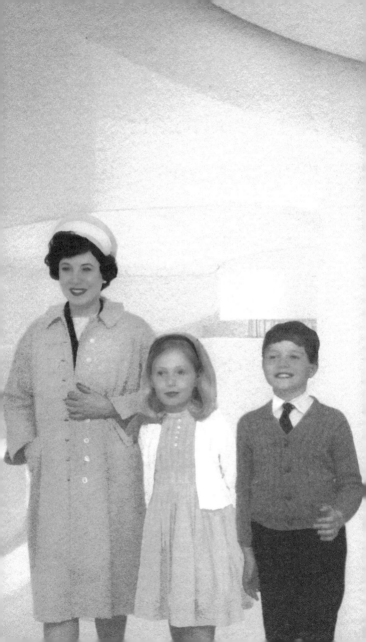

"Are you an artist?" says Susan.

"I couldn't become an artist because I had you," says Mummy.

John and Susan feel guilty.

new words guilty not artist

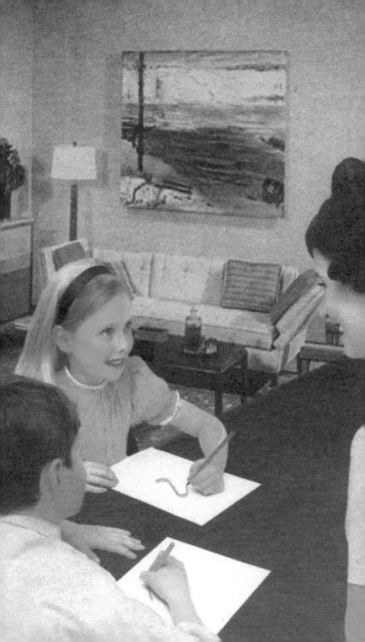

New words used in this book

Total number of new words 60

Dedicated to the big mummy in the sky.

Special thanks to photographer Tom Medwell, Ruth Pickett, Ros Frasier, Turnaround distributors, The Jealous gallery, The Cob gallery, James & James, Zaki Elia, Ruth Elia , Ezra Elia and the many people who have helped support this book.
First published 2014 ©